DRAW 50

Flowers, Trees, and Other Plants

THE STEP-BY-STEP WAY TO DRAW
Orchids, Weeping Willows, Prickly Pears,
Pineapples, and Many More . . .

BOOKS IN THIS SERIES

- *Draw 50 Airplanes, Aircraft, and Spacecraft*
- *Draw 50 Aliens*
- *Draw 50 Animal 'Toons*
- *Draw 50 Animals*
- *Draw 50 Athletes*
- *Draw 50 Baby Animals*
- *Draw 50 Beasties*
- *Draw 50 Birds*
- *Draw 50 Boats, Ships, Trucks, and Trains*
- *Draw 50 Buildings and Other Structures*
- *Draw 50 Cars, Trucks, and Motorcycles*
- *Draw 50 Cats*
- *Draw 50 Creepy Crawlies*
- *Draw 50 Dinosaurs and Other Prehistoric Animals*
- *Draw 50 Dogs*
- *Draw 50 Endangered Animals*
- *Draw 50 Famous Cartoons*
- *Draw 50 Flowers, Trees, and Other Plants*
- *Draw 50 Horses*
- *Draw 50 Magical Creatures*
- *Draw 50 Monsters*
- *Draw 50 People*
- *Draw 50 Princesses*
- *Draw 50 Sharks, Whales, and Other Sea Creatures*
- *Draw 50 Vehicles*
- *Draw the Draw 50 Way*

DRAW 50

Flowers, Trees, and Other Plants

THE STEP-BY-STEP WAY TO DRAW
Orchids, Weeping Willows, Prickly Pears,
Pineapples, and Many More . . .

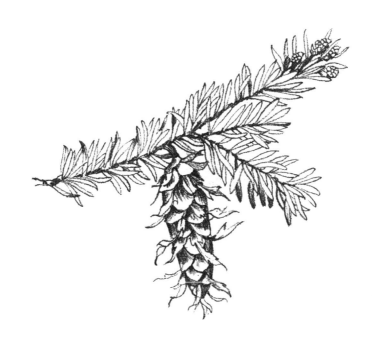

LEE J. AMES
with P. Lee Ames

WATSON-GUPTILL PUBLICATIONS

Berkeley

Published in the United States by Watson-Guptill Publications, an imprint
of the Crown Publishing Group, a division of Random House LLC,
a Penguin Random House Company, New York.
www.crownpublishing.com
www.watsonguptill.com

WATSON-GUPTILL and the WG and Horse designs are registered
trademarks of Random House LLC.

Originally published in hardcover in the United States by Doubleday,
a division of Random House LLC, New York, in 1994.

Library of Congress Cataloging-in-Publication Data

Ames, Lee J.
 Draw 50 flowers, trees, and other plants / Lee J. Ames with
P. Lee Ames. — 1st ed.
 p. cm.
1. Flower painting and illustration—Technique—Juvenile literature.
2. Flowers in art—Juvenile literature. 3. Plants in art—Juvenile literature.
[1. Flower painting and illustration—Technique. 2. Flowers in art. 3. Plants
in art.] I. Ames, P. Lee (Parsis Lee) II. Title. III. Title: Draw fifty flowers,
trees, and other plants.
NC805.A43 1994
743'.7—dc20 94-7192

ISBN 978-0-8230-8579-8
eISBN 978-0-7704-3292-8

Printed in the United States of America

13

2014 Watson-Guptill Edition

To Jocelyn,
who makes things
beautifully verdant . . .
always.

Author's Note

In recent books, I have worked with artists whom I consider to be superbly talented. All are top achievers and craftspeople, highly acclaimed by their colleagues and fans . . . and some have names and work you may recognize. This way we are making available to you other styles of drawing, techniques that are different from my own. With that in mind, I consider myself very lucky to have been able to persuade Persis Lee Ames to join with me in creating this book.

P. Lee Ames studied extensively at the Museum of Fine Arts in Boston and at the Art Students League in New York City. She then entered the commercial art field and developed a career in advertising, book illustration, jewelry design, and silver and greeting cards for Tiffany & Co.

Now that her children are grown, she works full-time on commissions for portraits, landscapes, and murals for interior designers and private clients. Her work can be found in private collections here and in Europe, and has been featured in major magazines and newspapers.

Mrs. Ames considers herself an illustrator of nature and a realistic painter. Flora is her specialty. She also excels in imaginative and whimsical trompe l'oeil and faux finishes. Recently she has studied at the Isabel O'Neil Studio in New York City, famed for its accomplishments in decorative arts. Her portrait paintings, murals, and screens demonstrate the artistic talents of this truly Renaissance woman.

And in case you're wondering, Persis and I are not related.

To the Reader

To be able to see and enjoy what you are seeing is much to be grateful for. But even more, being able to reproduce and convey to others, by drawing, what you see or imagine provides greater satisfaction. As in all my books, my purpose and pleasure are to show others, like yourself, a way to construct drawings.

This world is full of glorious things to see. I think you'll agree that the flowers, fruits, trees, and the rest of the subject matter here are testament to our beautiful world. In my earlier books, living subjects were all chosen from the animal kingdom. The other major kingdom in the tree of life is the vegetable kingdom, and almost all the drawings in this book are from there. The only exception is the mushroom, which is one of the Fungi.

When you start working, I suggest you use clean white bond paper or drawing paper and a pencil with moderately soft lead (HB or No. 2). Keep a kneaded eraser handy (available at art supply stores). Choose the subject you want to draw and then, very lightly and very carefully, sketch out the first step. Also very lightly and carefully, add the second step. As you go along, study not only the lines but the spaces between the lines. Size your first steps to fill your drawing paper agreeably, not too large, not too small. Remember the first steps must be constructed with the greatest care. A mistake here could ruin the whole thing.

As you work, it's a good idea to hold a mirror to your sketch from time to time. The image in the mirror frequently shows distortion you might not recognize otherwise.

You will notice that new step additions (in color) are printed darker. This is so they can be clearly seen. But keep your construction steps always very light. Here's where the kneaded eraser can be useful. You can lighten a pencil stroke that is too dark by pressing on it with the eraser.

When you've completed all the light steps, and when you're sure you have everything the way you want it, finish your drawing with firm, strong penciling. If you like, you can go over this with India ink (applied with a fine brush or pen) or a permanent fine-tipped ballpoint pen or a felt-tipped marker. When the drawing is thoroughly dry, you can then use the kneaded eraser to clean out all the underlying pencil marks.

Remember, if your first attempts at drawing do not turn out the way you'd like, it's important to *keep trying*. Your efforts *will* eventually pay off, and you'll be pleased and surprised at what you can accomplish. I sincerely hope you'll improve your drawing skills and have a great time drawing these beautiful plants.

LEE J. AMES

DRAW 50

Flowers, Trees, and Other Plants

The Step-by-Step Way to Draw Orchids, Weeping Willows, Prickly Pears, Pineapples, and Many More . . .

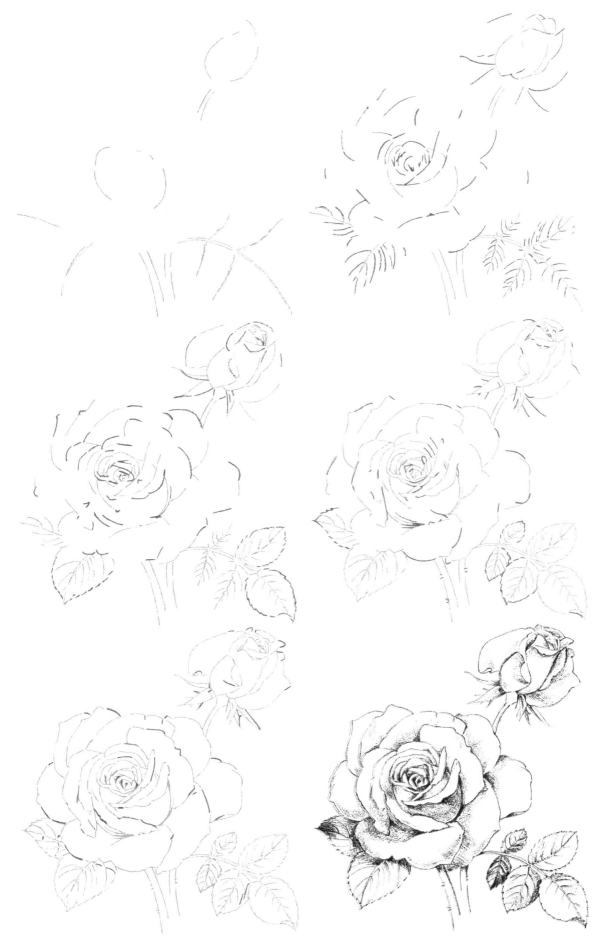

Rose
Family: Rosaceae
Genus: *Rosa*

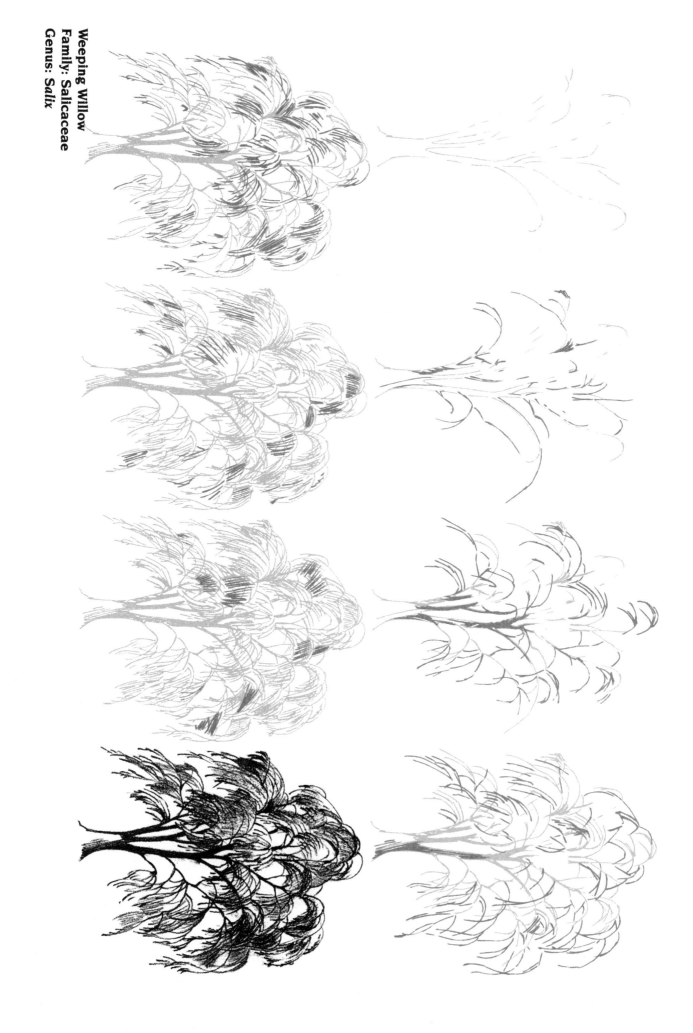

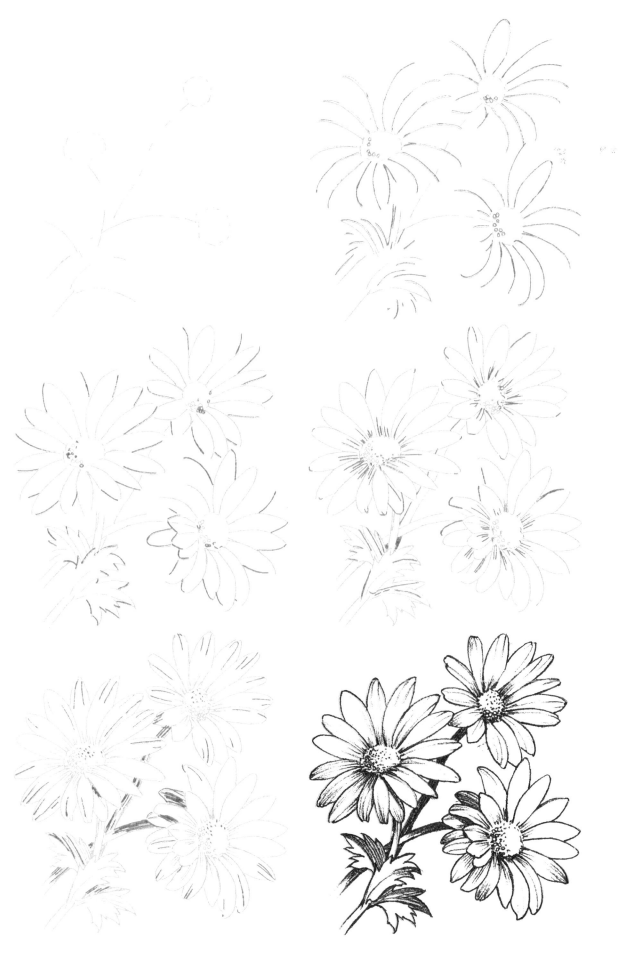

Daisy
Family: Compositae
Genus: *Chrysanthemum*

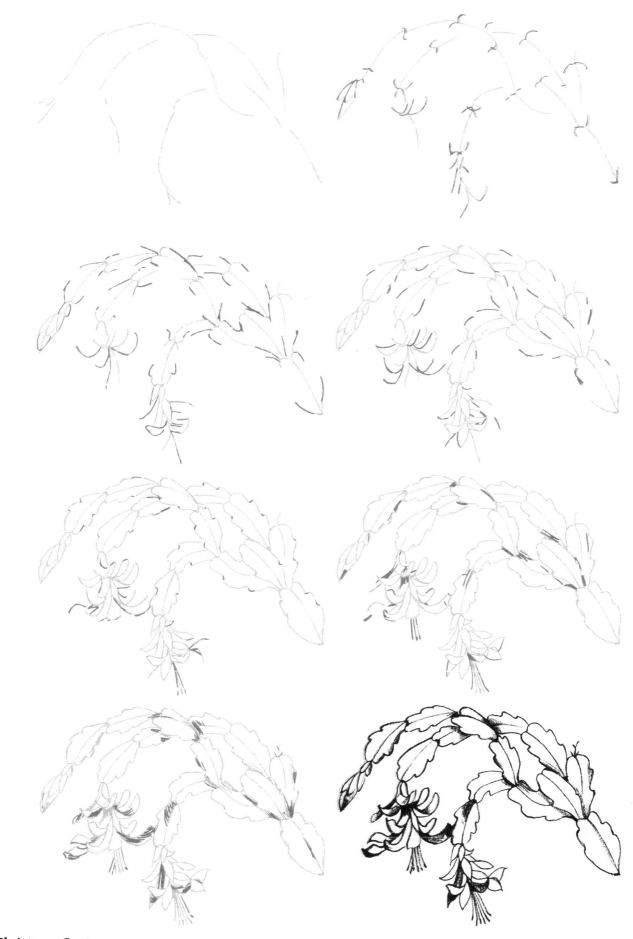

Christmas Cactus
Family: Cactaceae
Genus: *Schlumbergera*

White Pine
Family: Pinaceae
Genus: *Pinus*

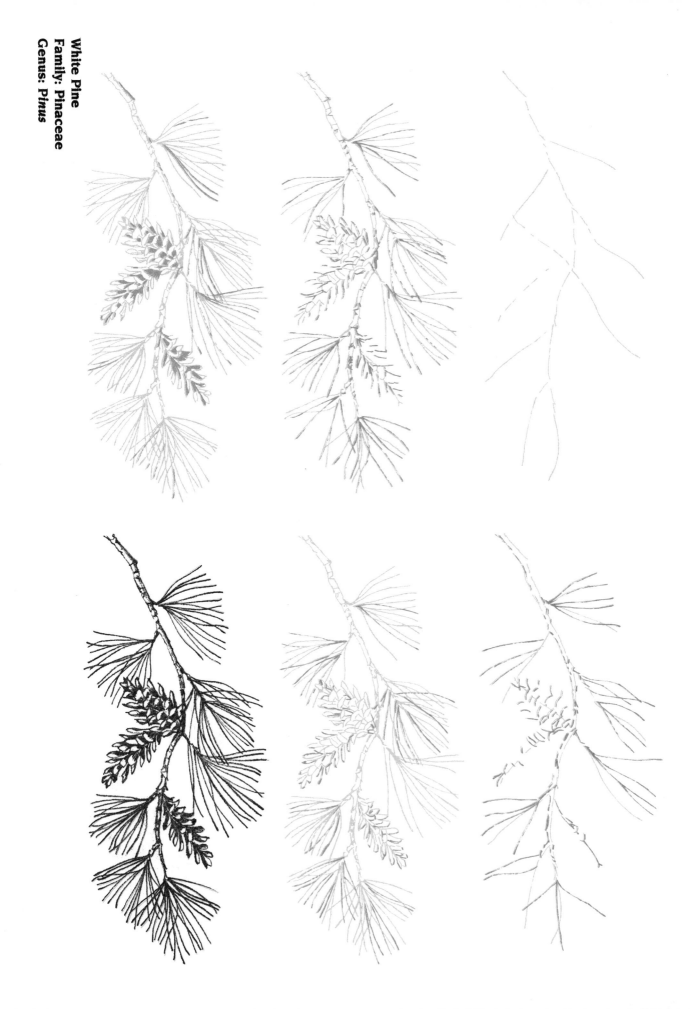

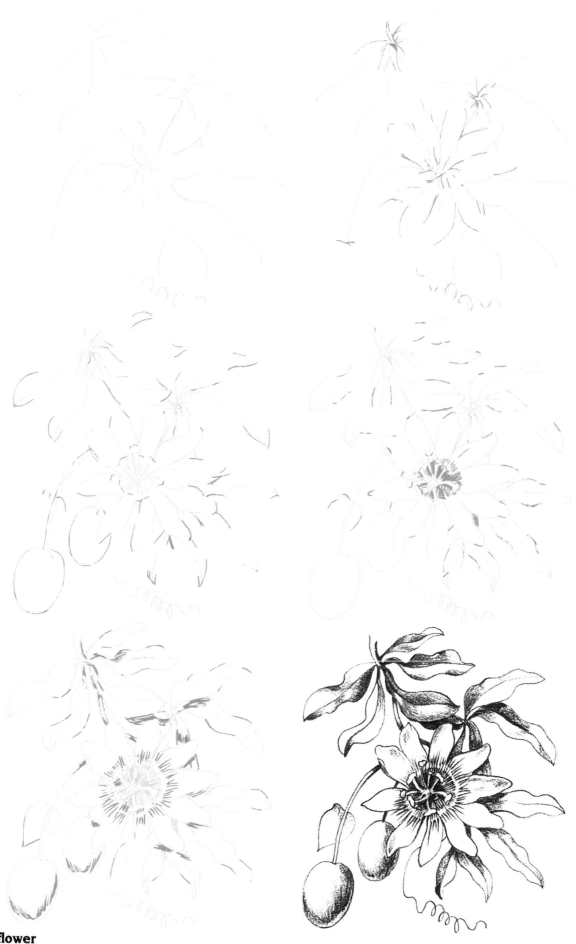

Passionflower
Family: Passifloraceae
Genus: *Passiflora*

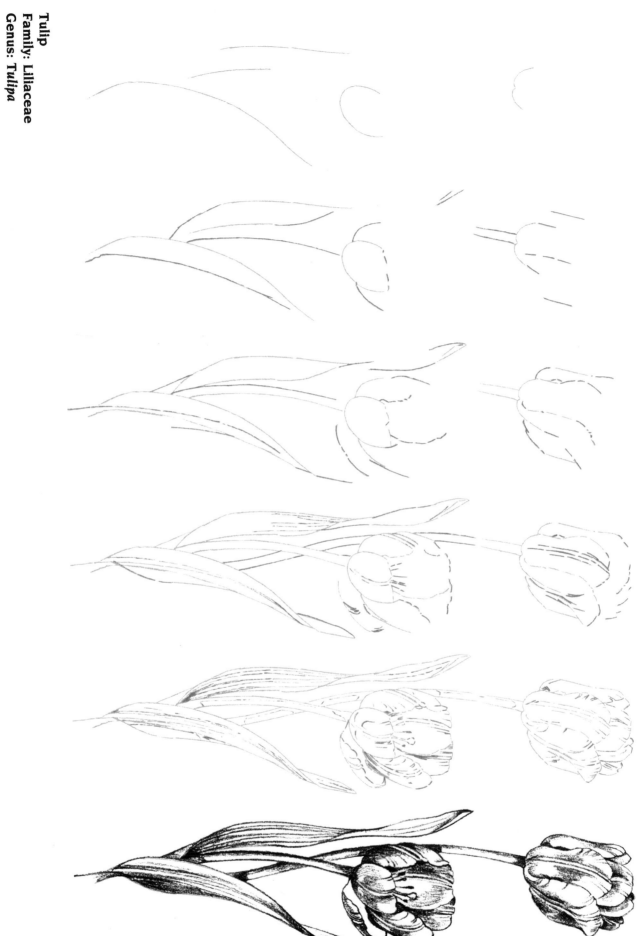

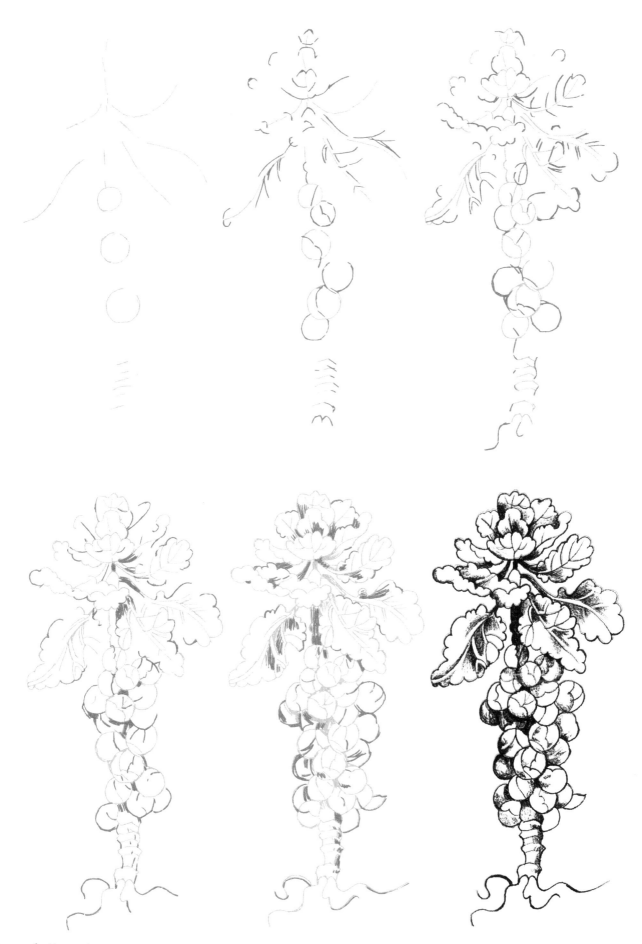

Brussels Sprout
Family: Cruciferae
Genus: *Brassica*

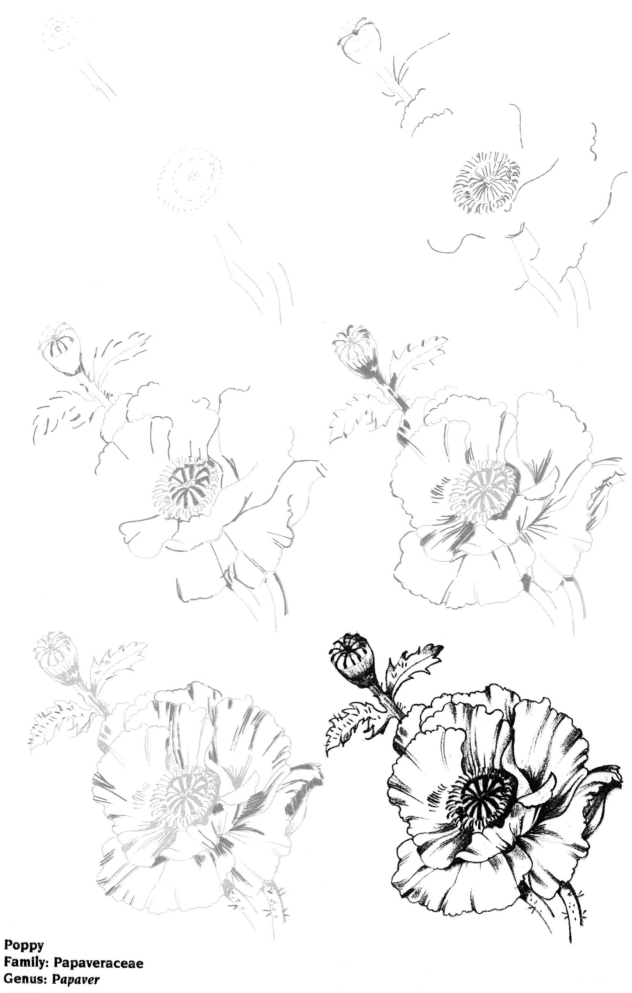

Poppy
Family: Papaveraceae
Genus: *Papaver*

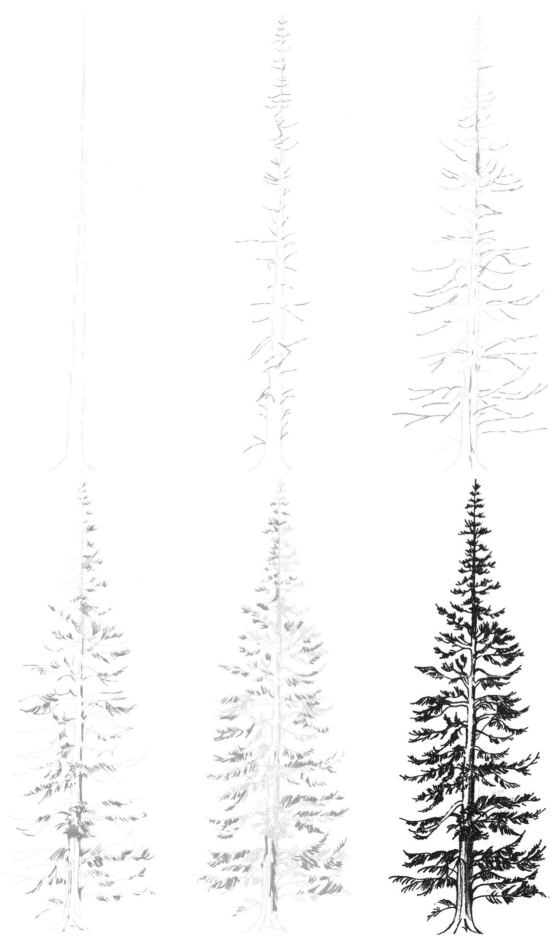

Fir
Family: Pinaceae
Genus: _Abies_

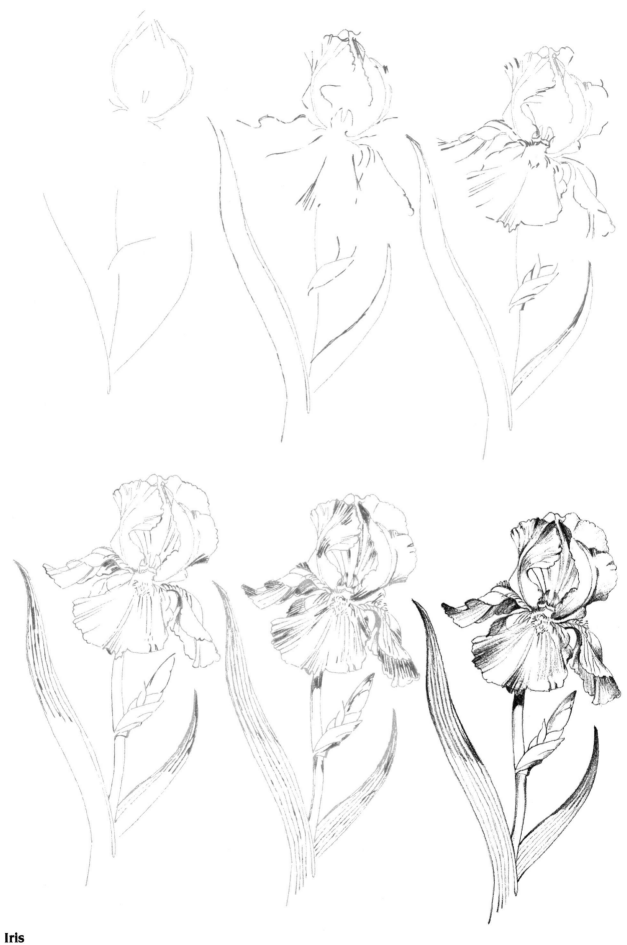

Iris
Family: Iridaceae
Genus: *Iris*

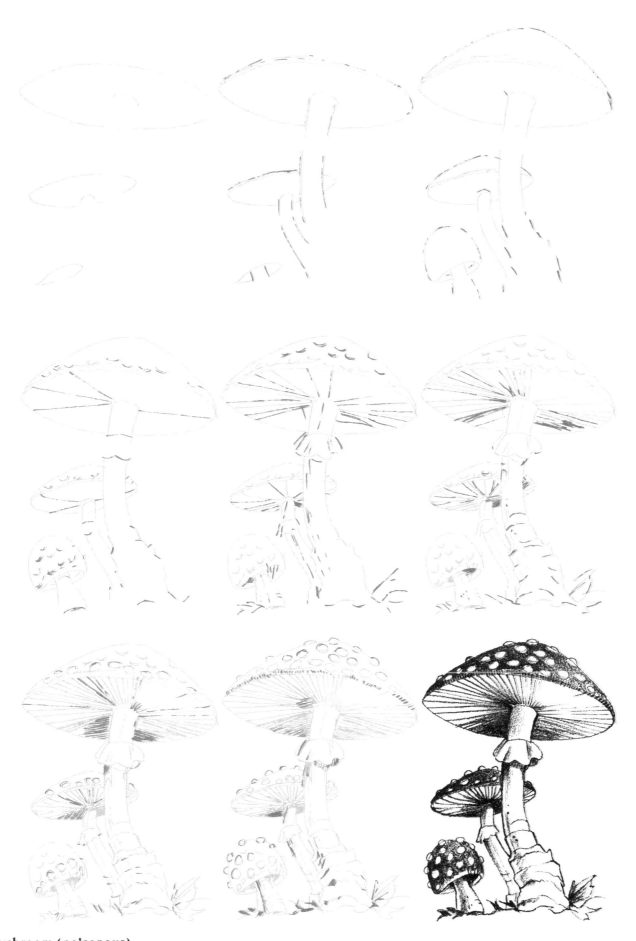

Mushroom (poisonous)
Family: Agaricaceae
Genus: *Amanita*

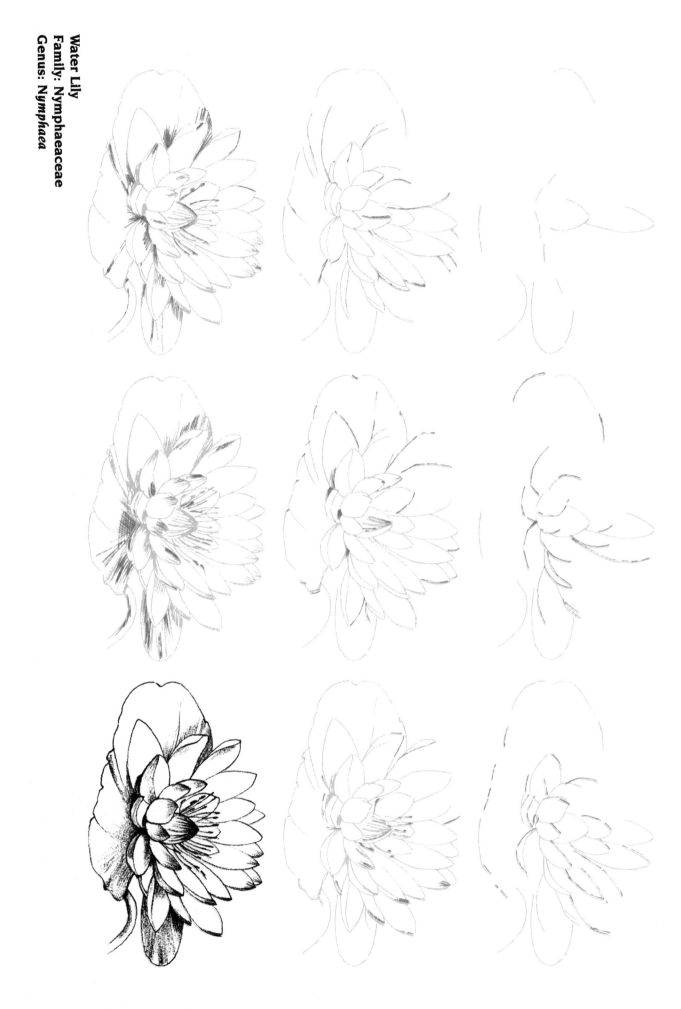

Water Lily
Family: Nymphaeaceae
Genus: *Nymphaea*

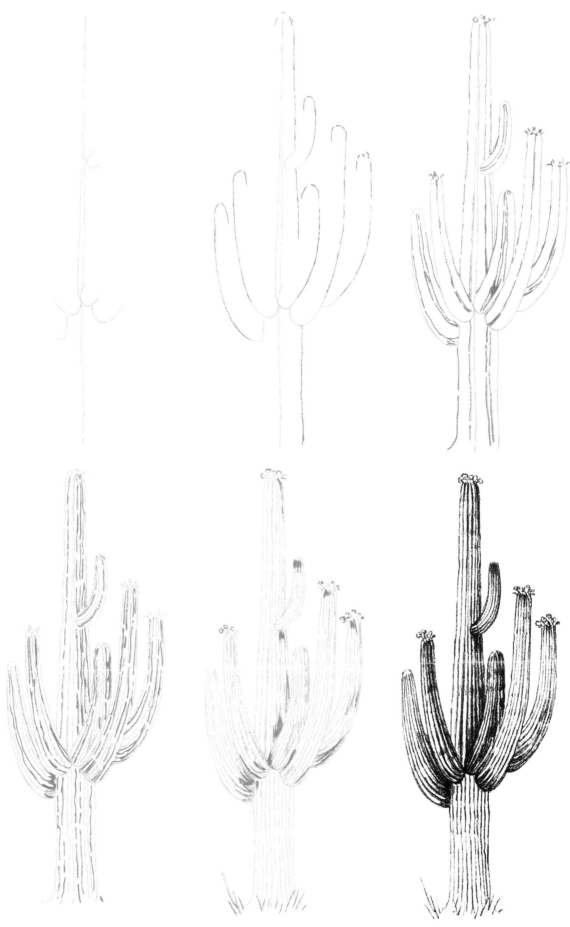

Saguaro
Family: Cactaceae
Genus: *Cereus*

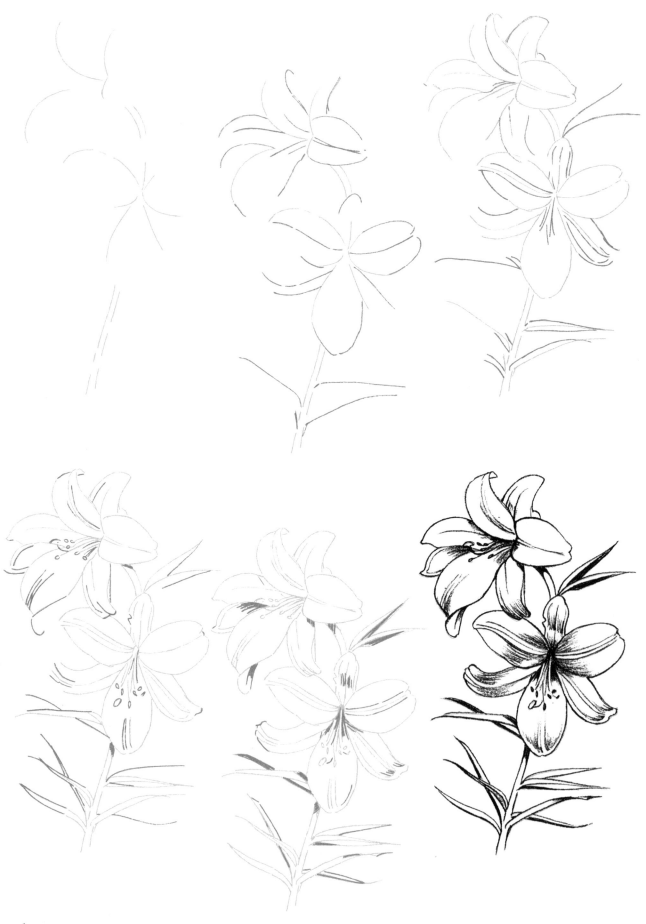

Madonna Lily
Family: Liliaceae
Genus: *Lilium*

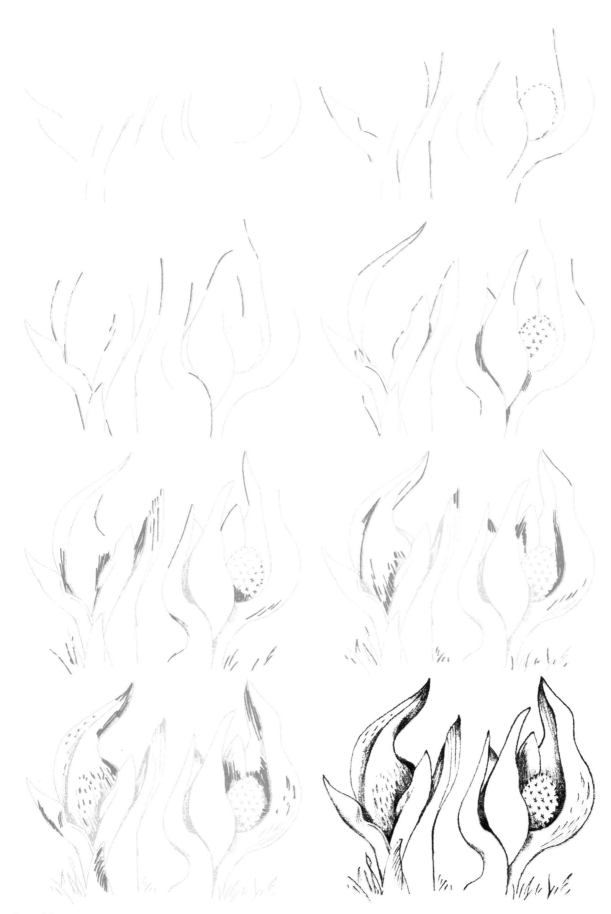

Skunk Cabbage
Family: Araceae
Genus: *Symplocarpus*

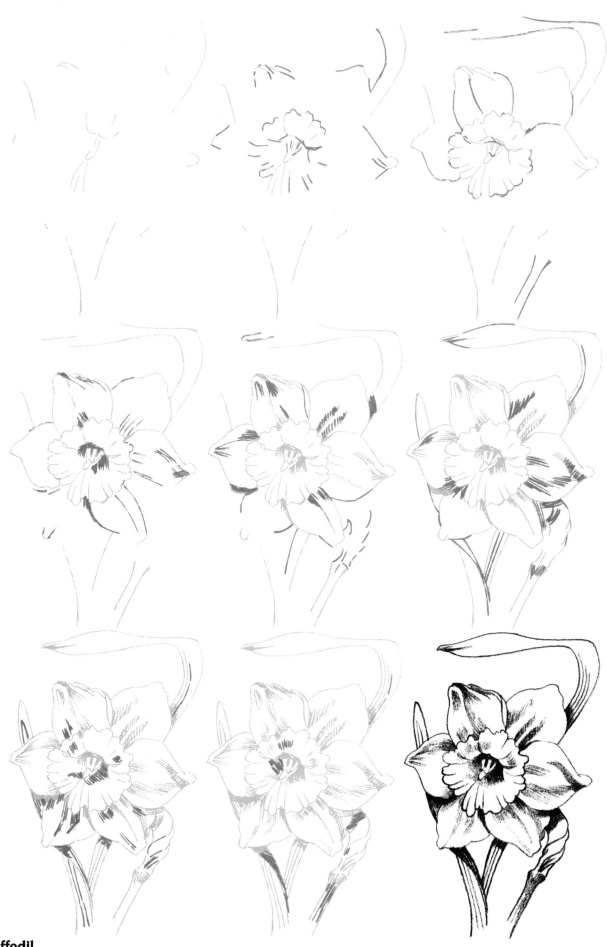

Daffodil
Family: Amaryllidaceae
Genus: *Narcissus*

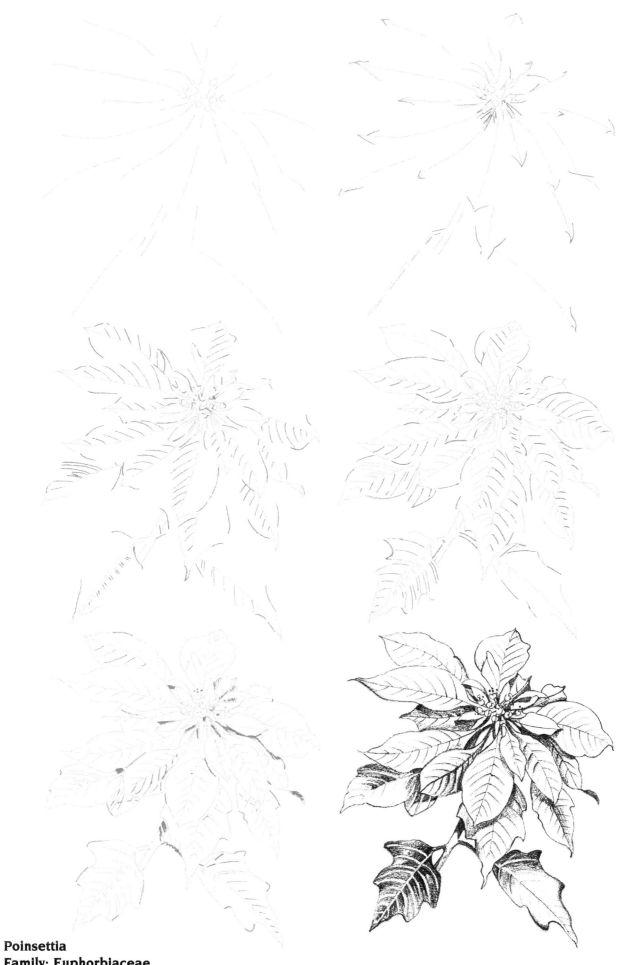

Poinsettia
Family: Euphorbiaceae
Genus: *Euphorbia*

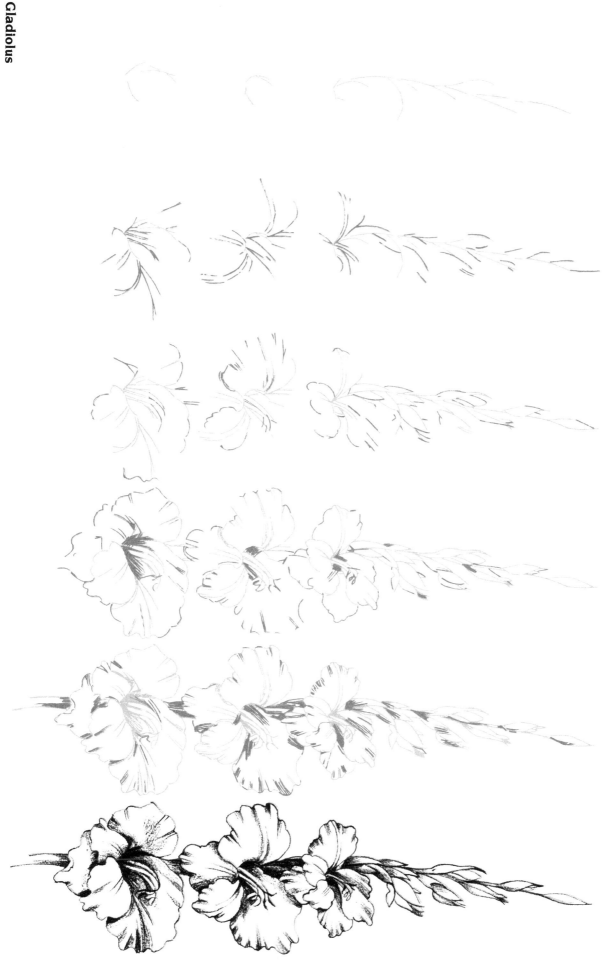

Baobab
Family: Bombacaceae
Genus: *Adansonia*

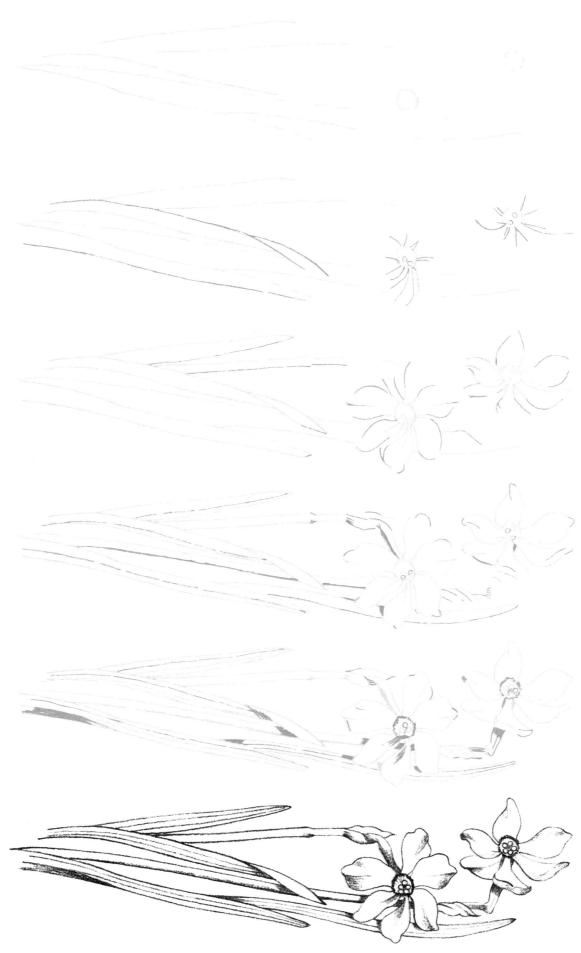

Peas
Family: Leguminosae
Genus: *Pisum*

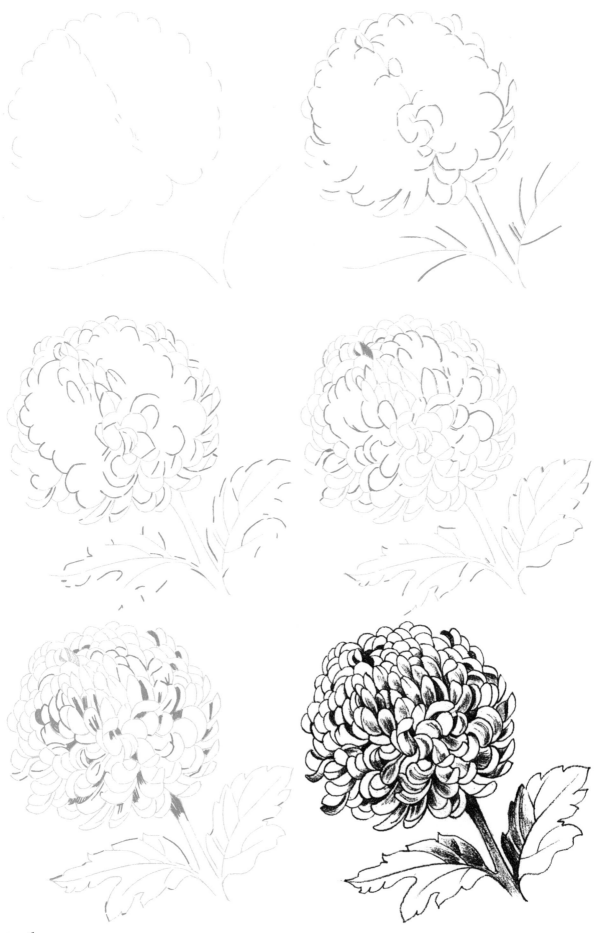

Chrysanthemum
Family: Compositae
Genus: *Chrysanthemum*

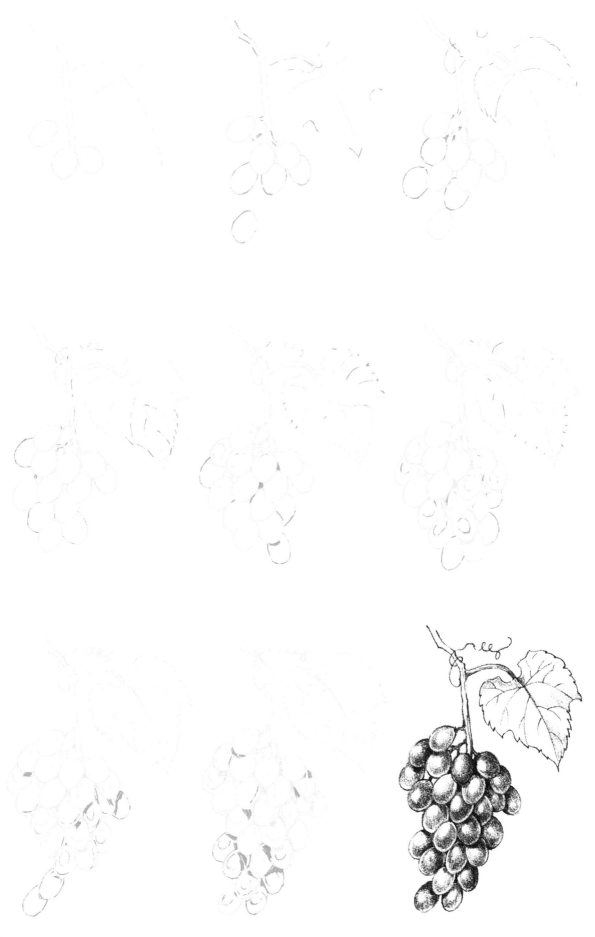

Grape
Family: Vitaceae
Genus: *Vitis*

Dogwood
Family: Cornaceae
Genus: *Cornus*

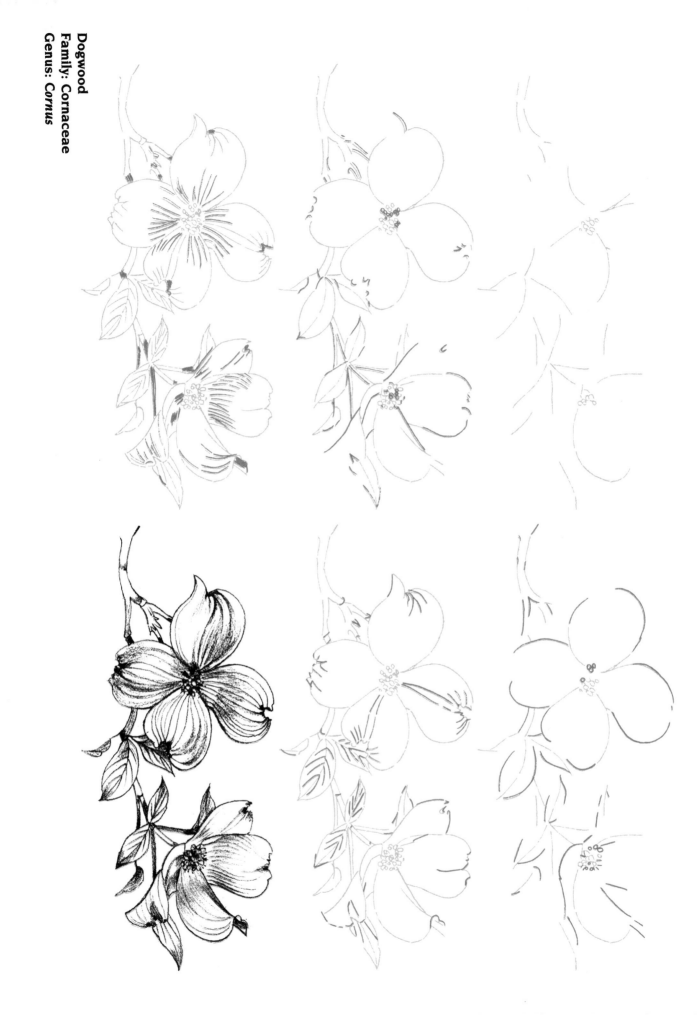

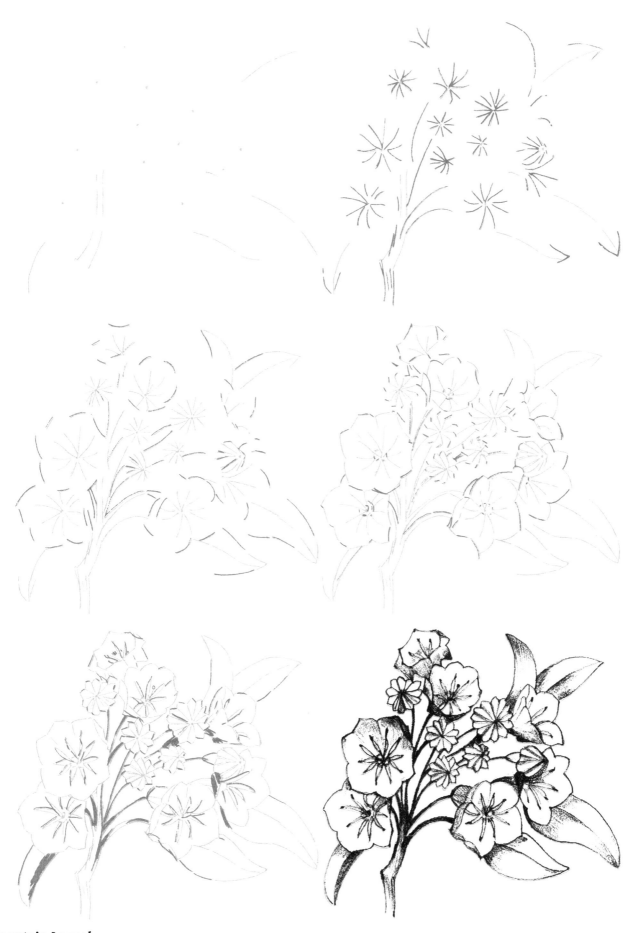

Mountain Laurel
Family: Ericaceae
Genus: *Kalmia*

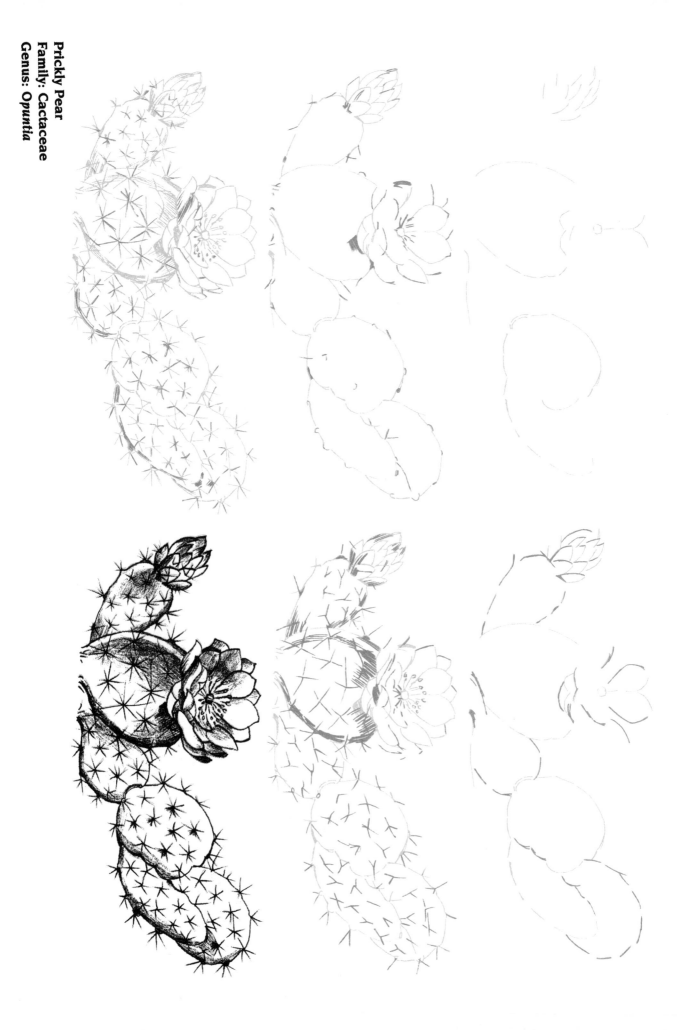

Prickly Pear
Family: Cactaceae
Genus: *Opuntia*

Giant Sequoia
Family: Taxodiaceae
Genus: *Sequoiadendron*

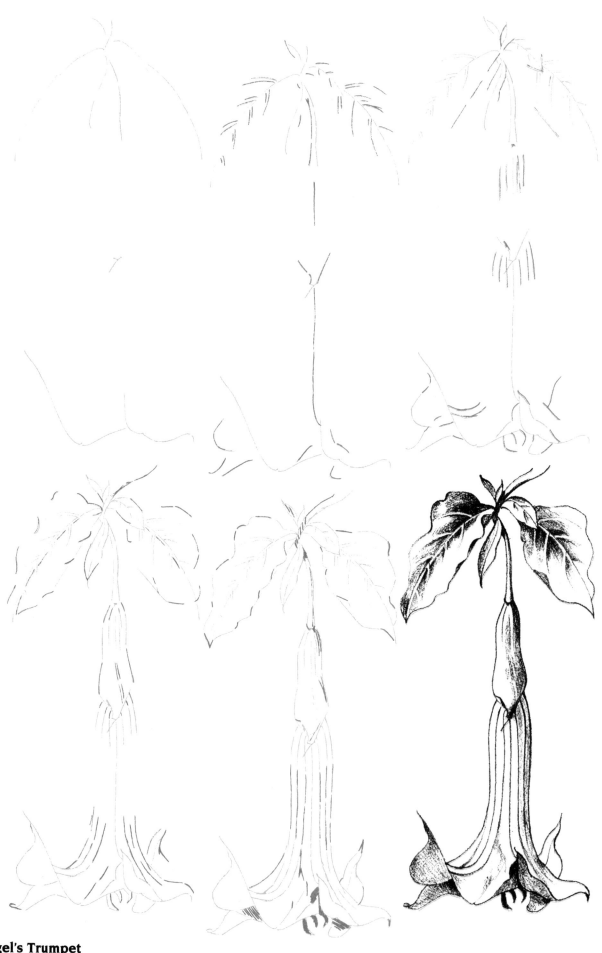

Angel's Trumpet
Family: Solanaceae
Genus: *Datura*

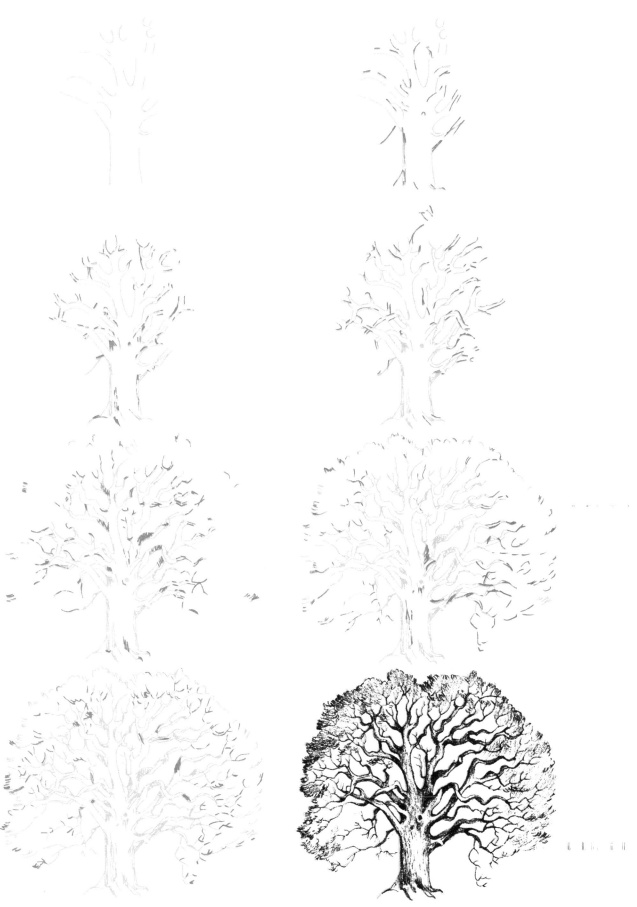

Oak
Family: Fagaceae
Genus: *Quercus*

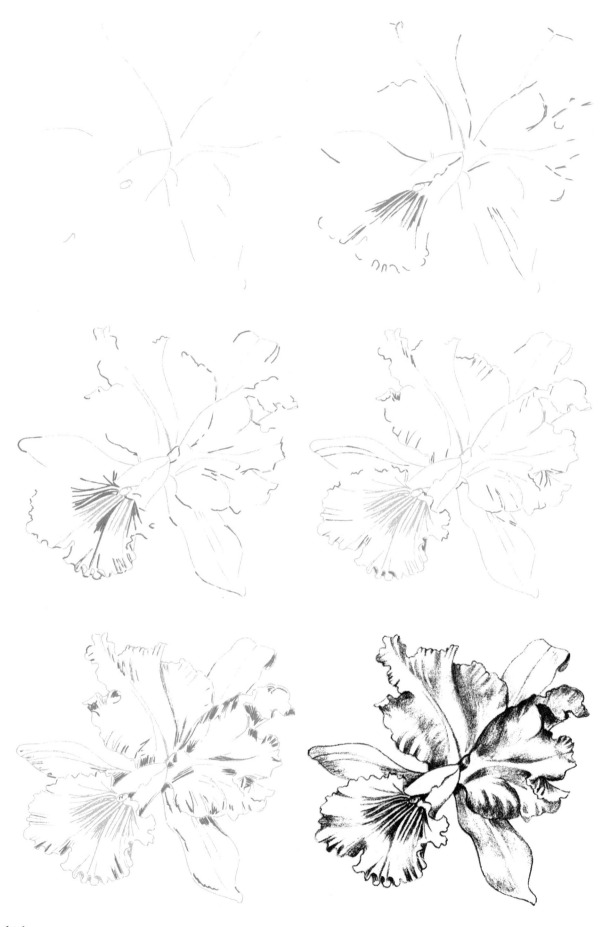

Orchid
Family: Orchidaceae
Genus: _Cattleya_

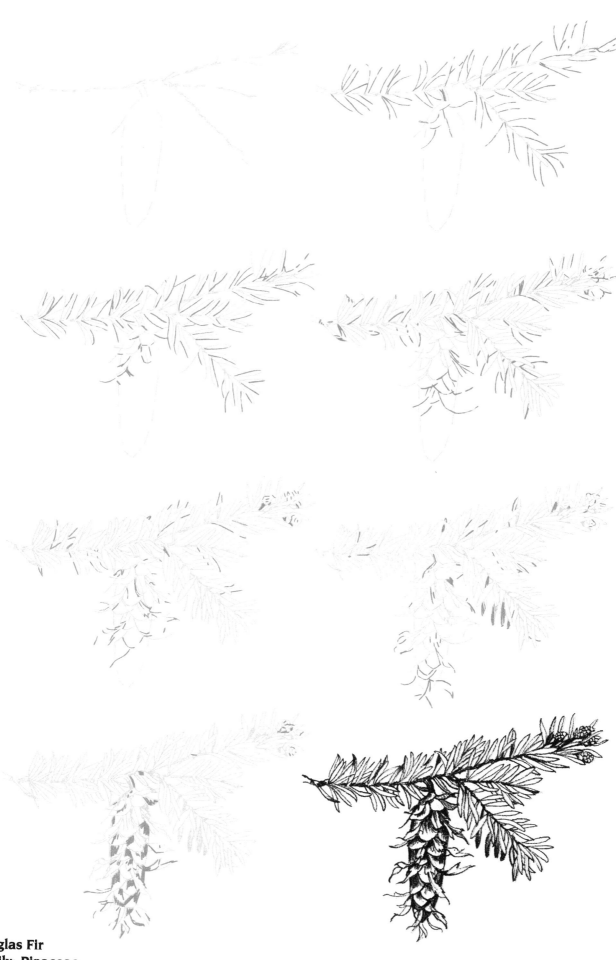

Douglas Fir
Family: Pinaceae
Genus: *Pseudotsuga*

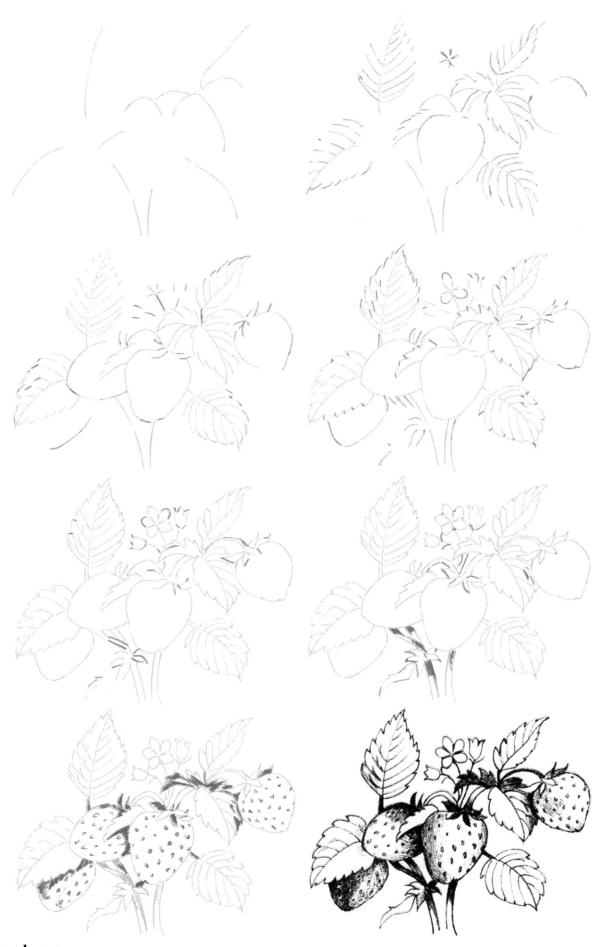

Strawberry
Family: Rosaceae
Genus: *Fragaria*

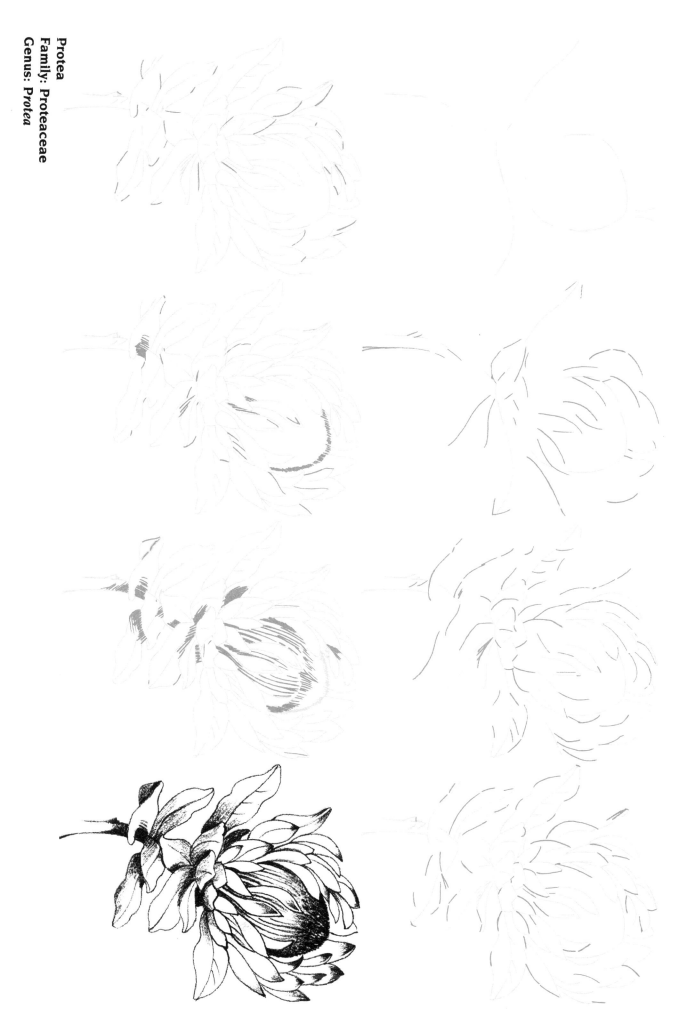

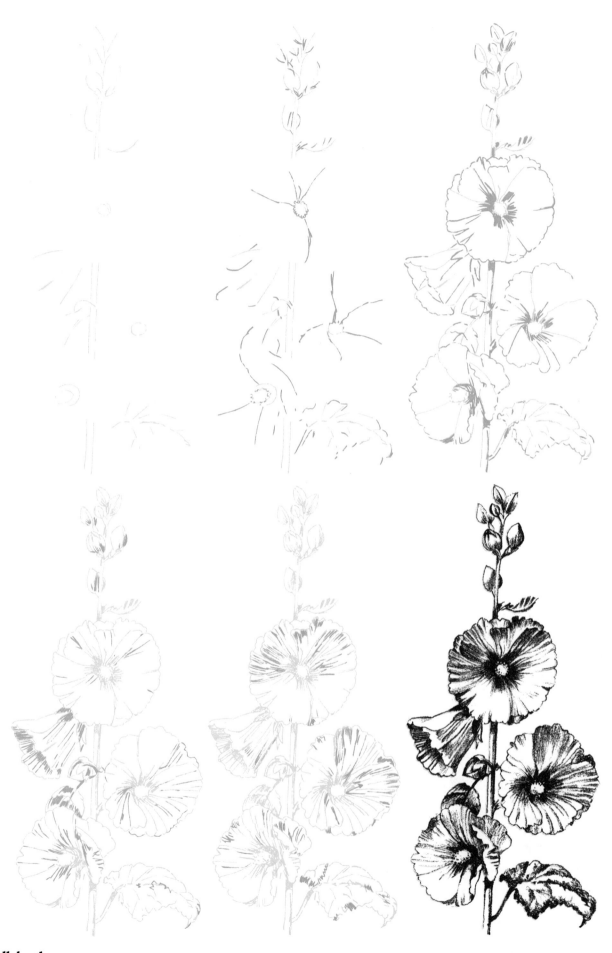

Hollyhock
Family: Malvaceae
Genus: _Althea_

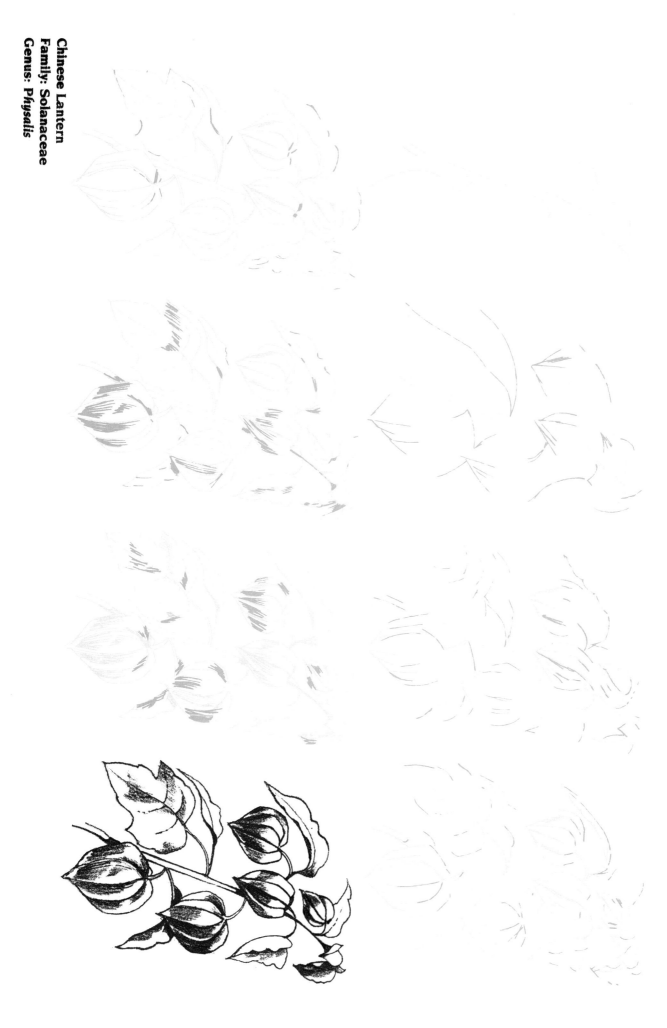

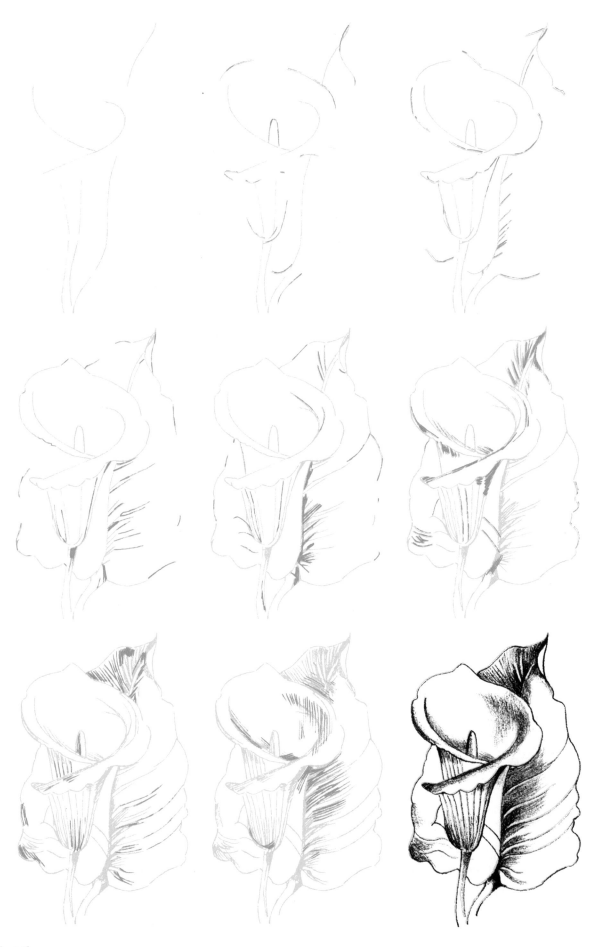

Calla Lily
Family: Araceae
Genus: *Zantedeschia*

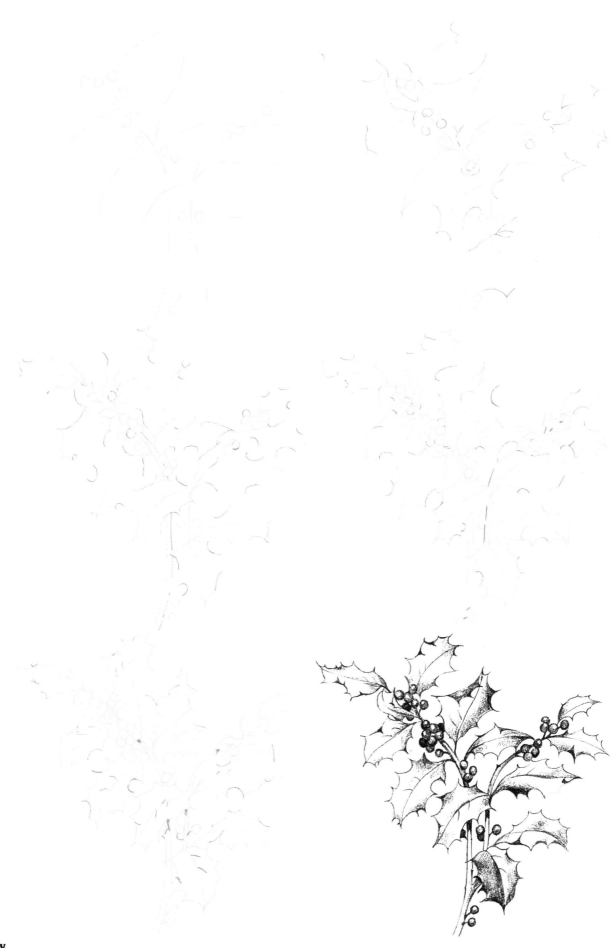

Holly
Family: Aquifoliaceae
Genus: *Ilex*

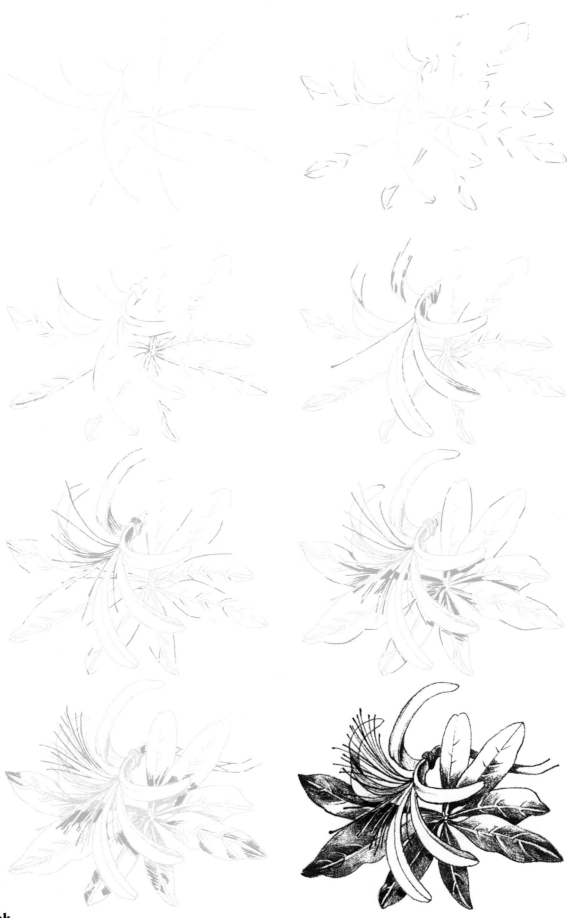

Kapok
Family: Bombacaceae
Genus: *Ceiba*

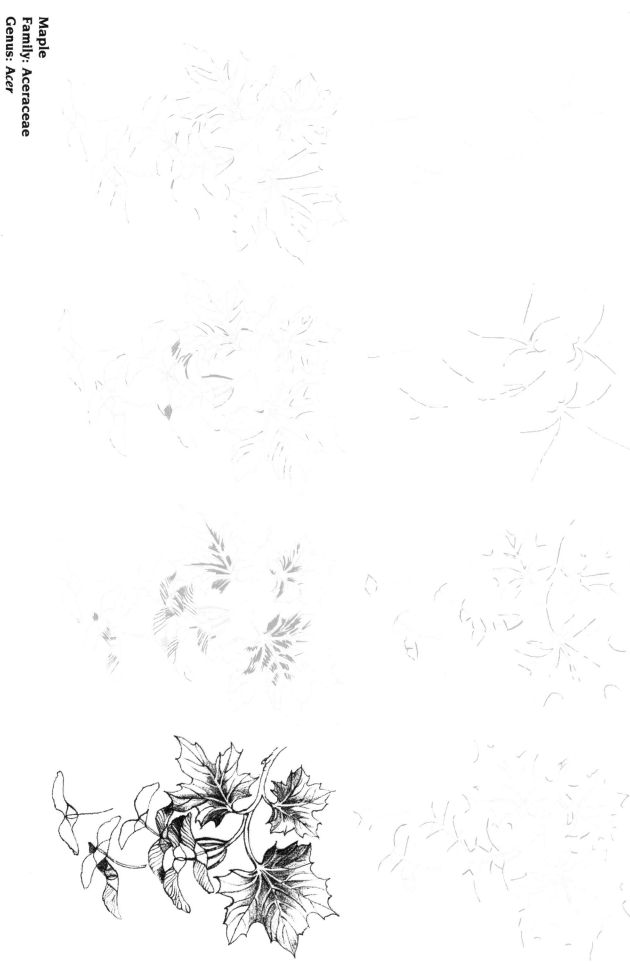

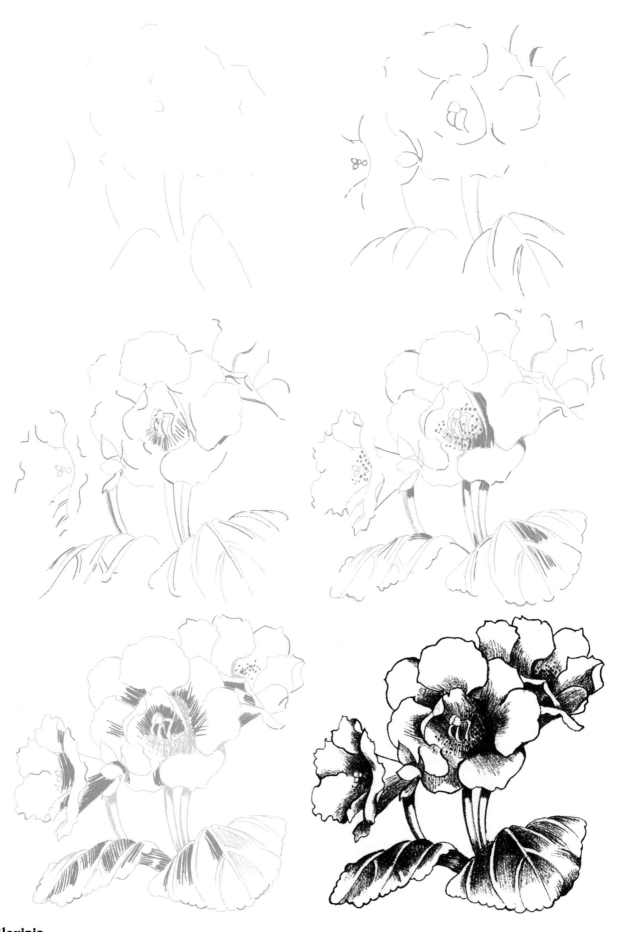

Gloxinia
Family: Gesneiaceae
Genus: *Sinningia*

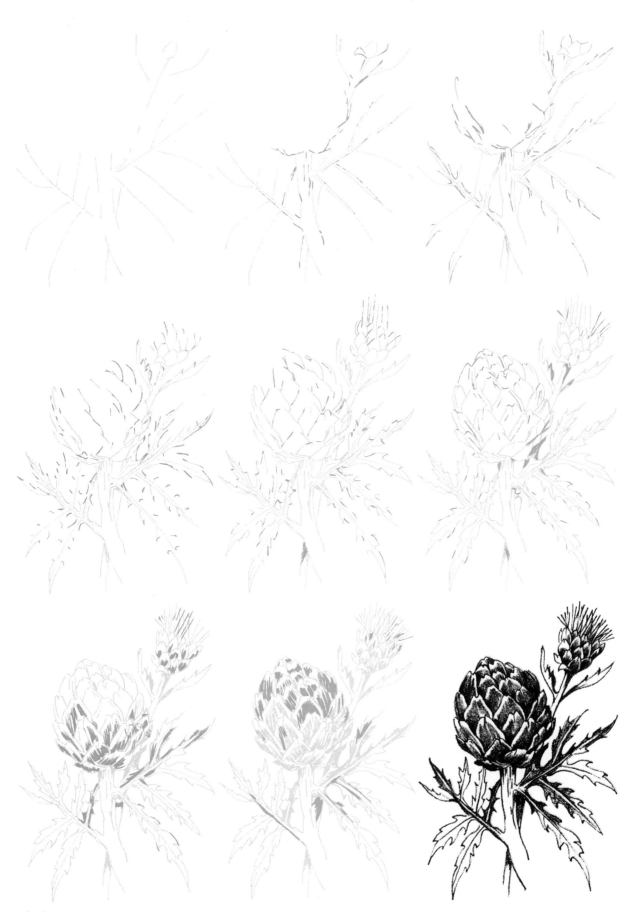

Artichoke
Family: Compositae
Genus: *Cynara*

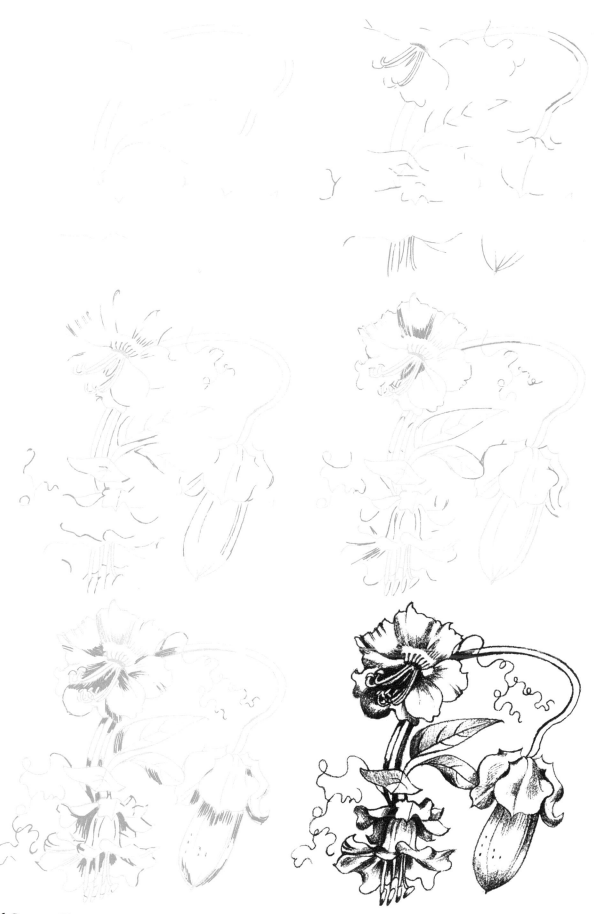

Cup-and-Saucer Vine
Family: Polemoniaceae
Genus: *Cobaea*

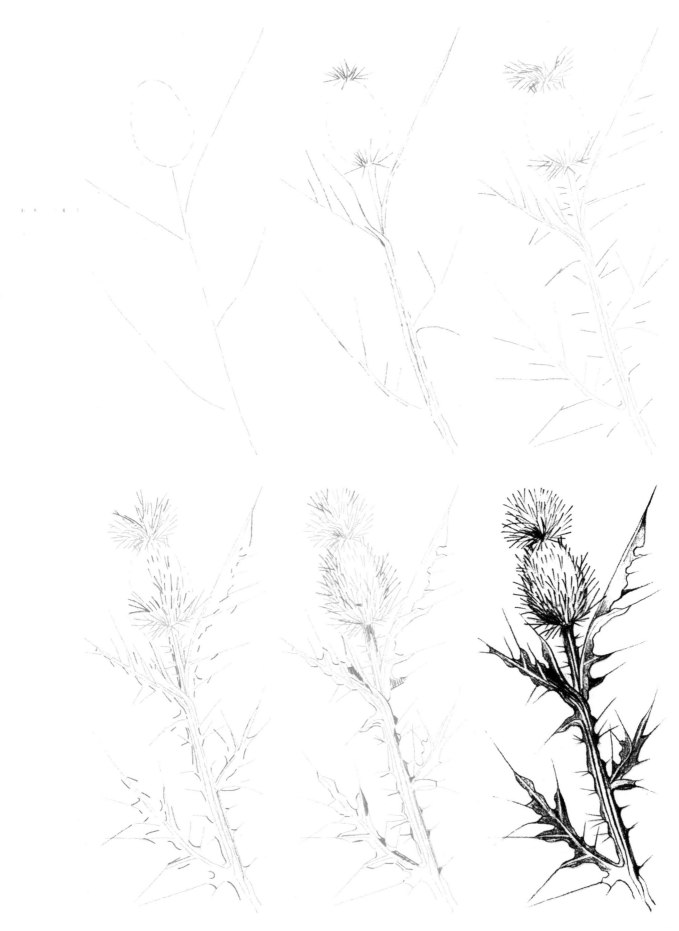

Thistle
Family: Compositae
Genus: *Cirsium*

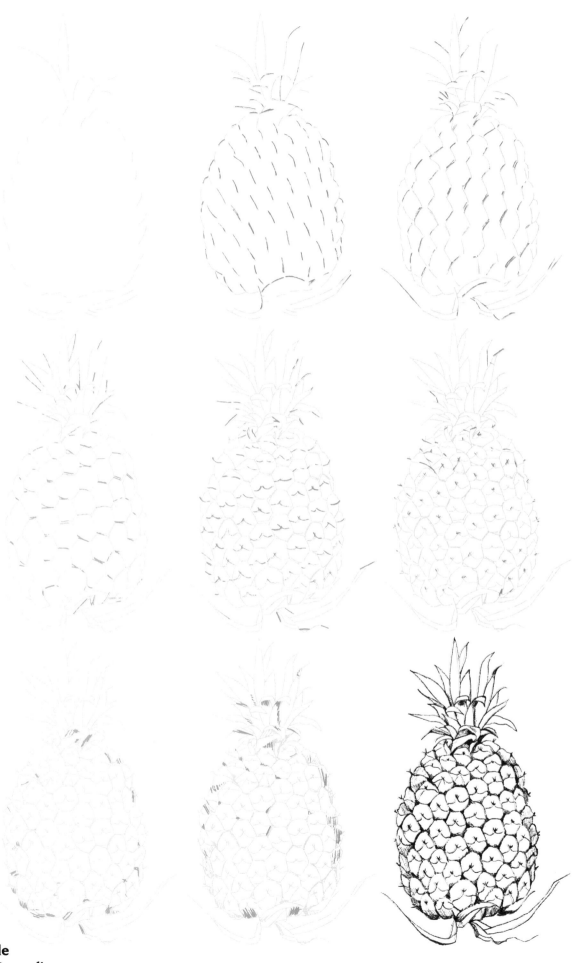

Pineapple
Family: Bromeliaceae
Genus: *Ananas*

Lee J. Ames began his career at the Walt Disney Studios, working on films that included *Fantasia* and *Pinocchio*. He taught at the School of Visual Arts in Manhattan, and at Dowling College on Long Island, New York. An avid worker, Ames directed his own advertising agency, illustrated for several magazines, and illustrated approximately 150 books that range from picture books to postgraduate texts. He resided in Dix Hills, Long Island, with his wife, Jocelyn, until his death in June 2011.

Persis Lee Ames studied at the Museum of Fine Arts School in Boston and at the Art Students League in New York City. After a professional career in the commercial art field, including advertising, book illustration, jewelry design, and silver and greeting cards for Tiffany & Co., she married and had four children.

DRAW 50 FLOWERS, TREES, AND OTHER PLANTS

Experience All That the Draw 50 Series Has to Offer!

With this proven, step-by-step method, Lee J. Ames has taught millions how to draw everything from amphibians to automobiles. Now it's your turn! Pick up the pencil, get out some paper, and learn how to draw everything under the sun with the Draw 50 series.

Also Available:

- *Draw 50 Airplanes, Aircraft, and Spacecraft*
- *Draw 50 Animals*
- *Draw 50 Athletes*
- *Draw 50 Baby Animals*
- *Draw 50 Cars, Trucks, and Motorcycles*
- *Draw 50 Sharks, Whales, and Other Sea Creatures*
- *Draw 50 Vehicles*